# VANITY

## PHOTOGRAPHS BY HOLLY WRIGHT

September 10 – November 13, 1988

The Corcoran Gallery of Art

Washington, D.C.

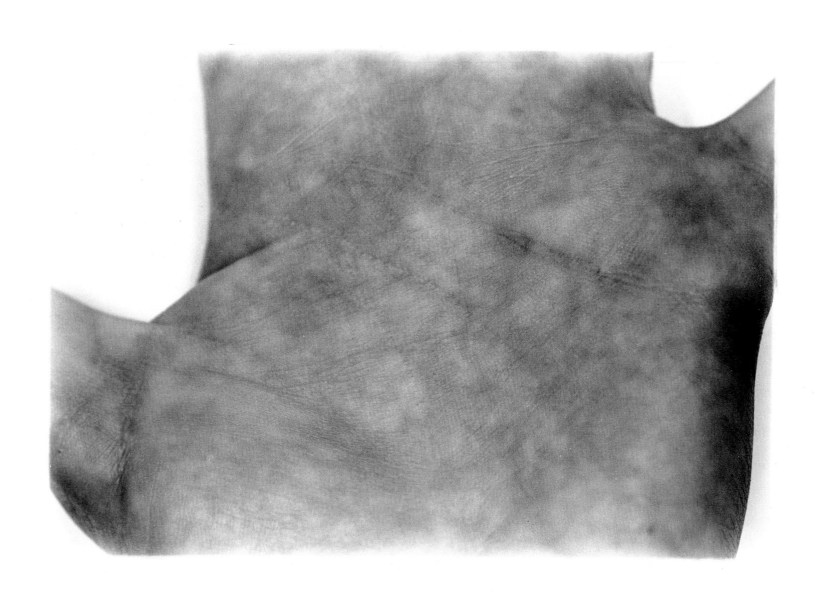

# PHOTOGRAPHS BY HOLLY WRIGHT

Holly Wright began her professional life as an actress. She has successfully transformed that career, and all the knowledge and skills it conveys, into a life as a photographer. This fact of her history bears greatly on the nature of her vision. For, at least as it seems to me, her best photographs are both deeply theatrical, and essentially *literalist,* in the sense of the dramatic arts.

Theater and photography can never share in the temporal dimension: one takes place in extended, evanescent, real time; the other in chronological micro-instants, leaving unerasable traces. So the two art forms are not often associated. Yet in certain (rare) hands, the still camera partakes in a fundamental aspect of the dramatic arts: it engages a close, even *forced* connection with human gesturalism.

Among the first of Holly Wright's photographs I saw was a series made in the early 1980s, picturing some of her friends and family and acquaintances in a peculiarly histrionic, if basic act: that of simply, with abandon, *applauding.* These photographs, seen together, created a sense of an eerily present gathering of spirits, sharing a common experience of displaying enthusiasm to a photographer. Each picture summoned an eager, open, slightly enraptured or distorted face; each encompassed a pair of clapping hands, tensely suspended in mid-air or clasped in the moment of resonant impact.

This cycle of work struck me as beginning to invent a genre that was half-photographic, and half-dramatic—it even seemed to verge on the cinematic. Its unifying device was a conceit based in real theater; and the sense one had, when seeing these images together, was of being quite physically in the presence of the personalities of these people who consented to applaud for Holly. The art of performance rather than that of plain still photography, threatened to win out. And yet, these were the simplest of photographs—painstakingly printed in black and white, untricked, carefully framed in the lens, and presented in the best tradition of "straight" art photography.

What one knew, then, about Holly Wright's strength as an artist had to do with a certain interest in *seriality* in her imaging; and a distinct taste for intimate physical contact with her subjects. Yet it was difficult to see where she might take her work from the point she had reached with both the applause photographs, and others of the same vintage that repeatedly explored the personae of people around her. (She most often used family and friends as her subjects.) Difficult, because to come so close to a number of photographed subjects as she did, seemed to offer little but an increasingly unvarnished exposure of psychological or physical nakedness, a tendency that, for lack of knowing when to stop, sometimes defeats photographers.

No one could have predicted Holly Wright's amazing next move. The often-depicted subjects' hands that had already produced so much gestural expressiveness in her work, apparently suggested the vehicle for another drama. This new scene wrenched her away from the self-vis-a-vis-object, that relationship that photography is about. This dislocation took as its subject nothing less than the endless seductions and mysteries of one's own flesh. The *others* Holly Wright had photographed repeatedly, were abandoned, to be replaced by her closest resource—her own making hands. Yet in the moment she turned to herself for her subject matter, the photographs became impersonal. She moved abruptly closer to still photography's own primal attributes; the cinematic potential in much of the earlier work seems, at least for the time being, to have been retired.

The body of work presented here represents three years of concentrated effort. She began to work on these images in the summer of 1985, using a 2¼″ camera or 35mm equipment with various screw-on magnifying lenses, whatever worked. Holly herself speaks half-ruefully of these images as an exercise in vanity: "This whole thing," she has said, "is a losing battle, a vain endeavour. In any event, I hope I'm avoiding what Charles [her husband] calls the Look-At-Me theory of art."

Yet we, the audience, cannot quite agree with this modest characterization of the work. An interesting contradiction lying at the heart of these images removes them from any ordinary implication of narcissism. Just because they are, in a way, self-involved to the point of onanism—this wild array of bodily surfaces is only the skin of the photographer's own hands—does not mean that the works in themselves signal any narcissistic, or "vain" intent. On the contrary. They are far more universal, far more abstract, and, most of all, more *immediate* in their presence, than

most straight photographs of "the other" ever seem to be. Moreover, they communicate so directly to their viewers as to strip away most of the usual stylistic armor thought to be basic to successful art photography.

Whereas most photography, whether amateur or professional, journalistic or aesthetic, seems somehow descriptive, analogic, mnemonic in nature, this work is irreducibly literal. Insofar as it is possible for art to be "convulsively" present—in the sense of the Surrealists' striving toward this state in visual images—these photographs succeed. Indeed, the best counterparts to this work of Holly Wright's are certain photographs by Jacques-Henri Boiffard, Dora Maar or Man Ray, from the 1920s and 30s.

For photographs to be other than illustrational, they must sometimes transcend their own subjects. If we think of Holly Wright's sexually fraught, polymorphously sensual pictures presented here as a prolonged meditation on eroticism and its companion, death, we see that a transcendent state has successfully been achieved. In a single swift move, these photographs arrived at a scene beyond the drama of their making: they refer, through an extraordinarily elastic set of operations, to fleshliness itself. In the words of Richard Howard, "What we are responding to … is not [merely] the sexual, the genital nature of these figures in their touching juxtapositions, for this is a somatic encounter without gender markers, but the overwhelming sense of muscular structure beneath the skin—*failing* the skin rather than filling it. What is revealed is the sense of pathos about the somatic necessity for flaccidity if there is to be tension."[1]

It should be plain that I have some qualifications in accepting Holly Wright's own (gentle, self-questioning) identification of this work as an exercise in self-involved vanity. Yet, if we consider the word, *vanitas*, in its original sense, we circle around to the artist's meaning in so naming this cycle of photographs. It is not narcissistic, ego-attached vanity we are reminded of, but that more archaic vanity—the one that is identified in medieval and Renaissance iconography with the skull, or the scythe. It is simply the inescapable transiency evinced in the full view of beautiful quick flesh. The sacred, individual, finite body—at every minute and in each movement—expresses its infinite (mortal) nature.

On another level, as formal works of art, these photographs will be seen as boldly scaled, richly nuanced, sharply arresting compositions whose ontological nature is perhaps dimly felt. Their sheer scale, printed large, crowding the view-frame, assures a strong initial response. The tiny moment of doubt as to *what they depict,* catches us up in an unusually vivid thrall to the images, even before we know what to make of them. And perhaps this immediate engagement between the viewer and the photographer is all one should ask of a successful body of work. The monolithic commandingness of these images, and the shrewdly inventive intelligence behind them, place their author, in one stroke, at the forefront of contemporary photography.

Jane Livingston

[1] Richard Howard. "One Flesh," see bibliography.

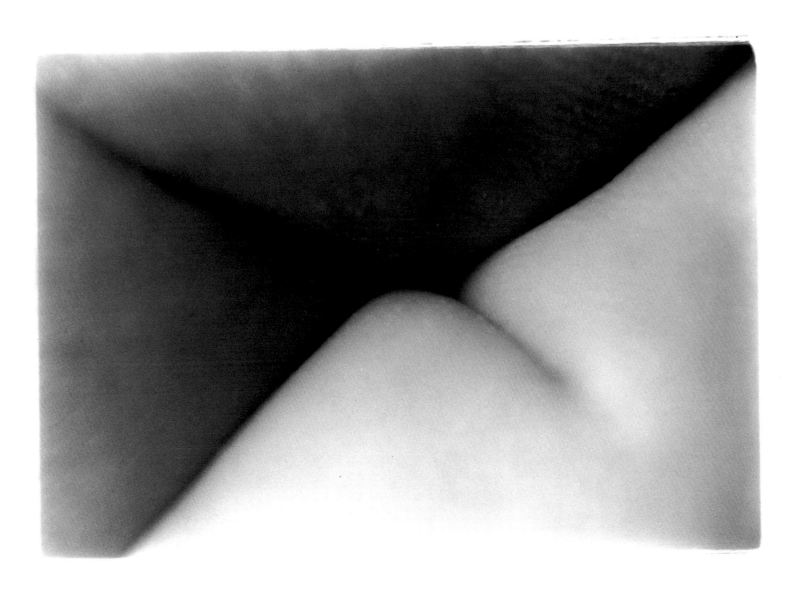

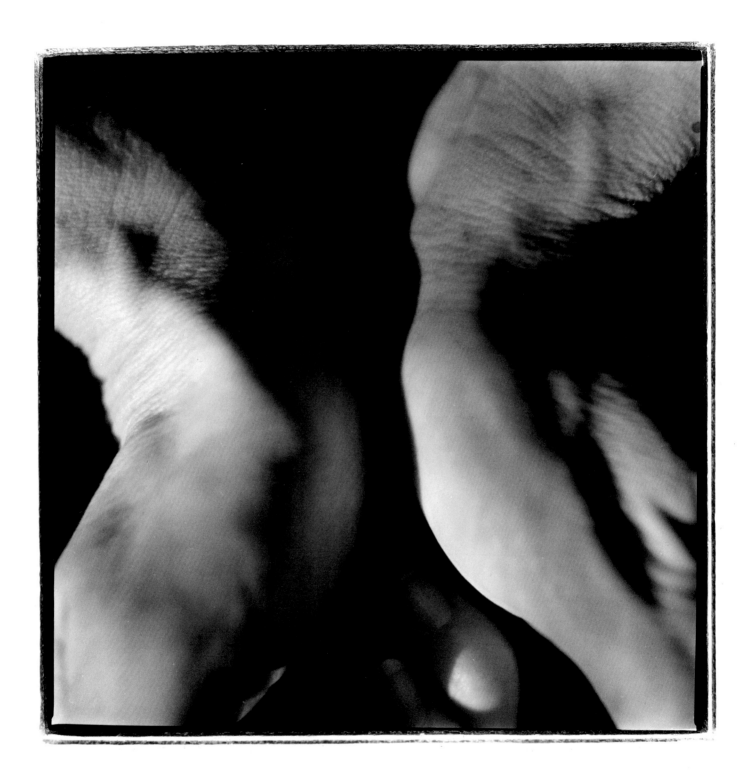

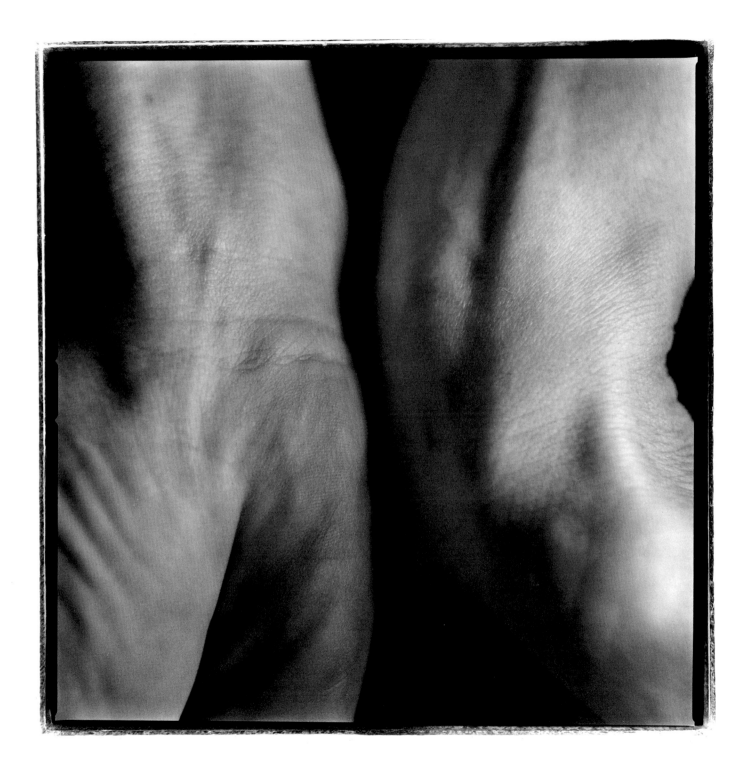

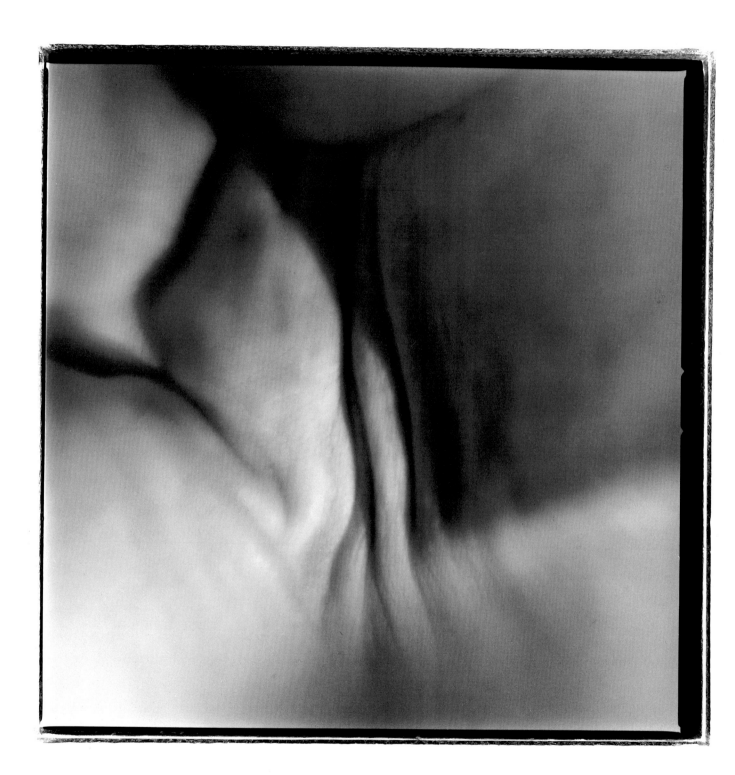

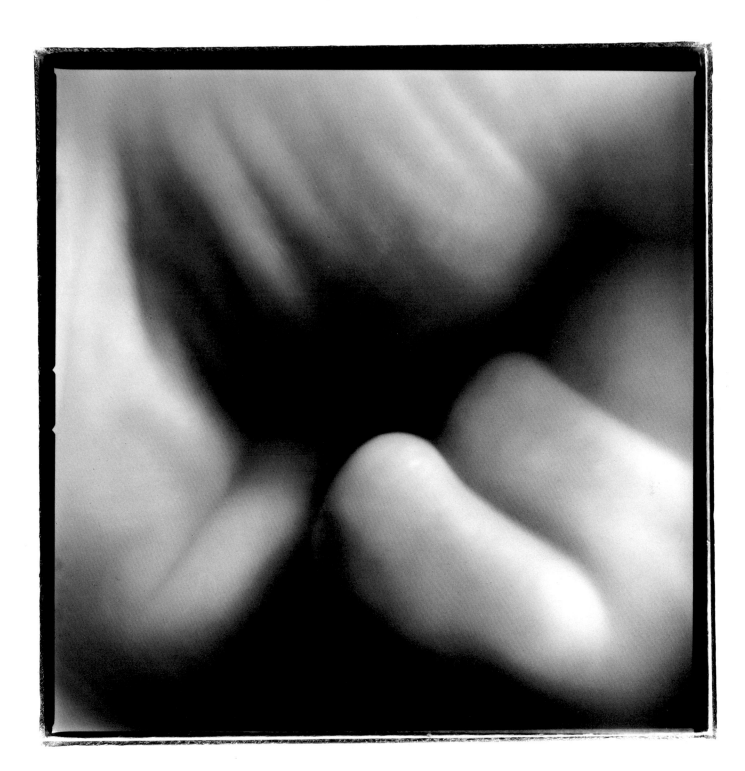

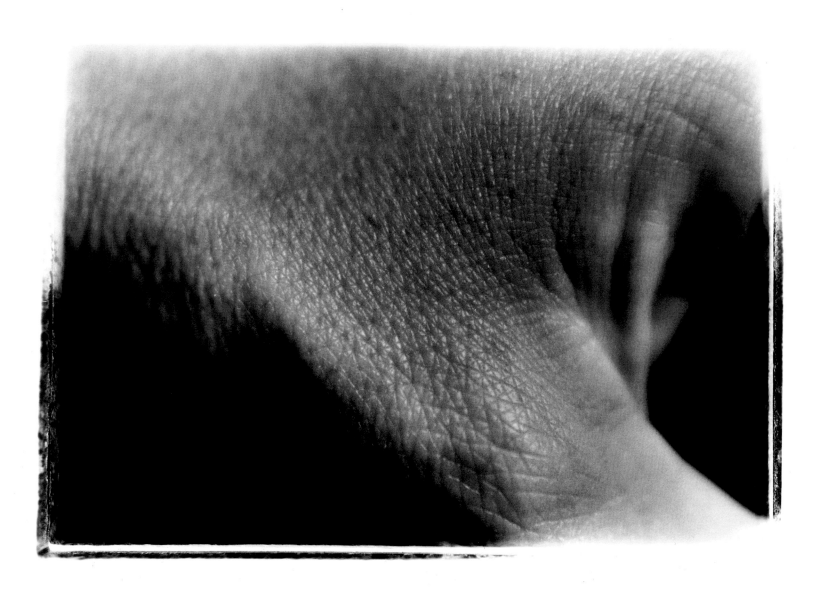

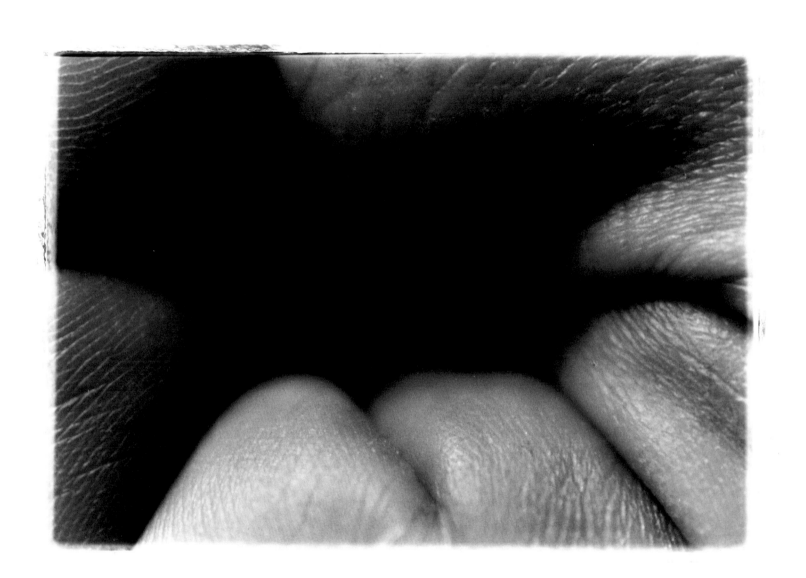

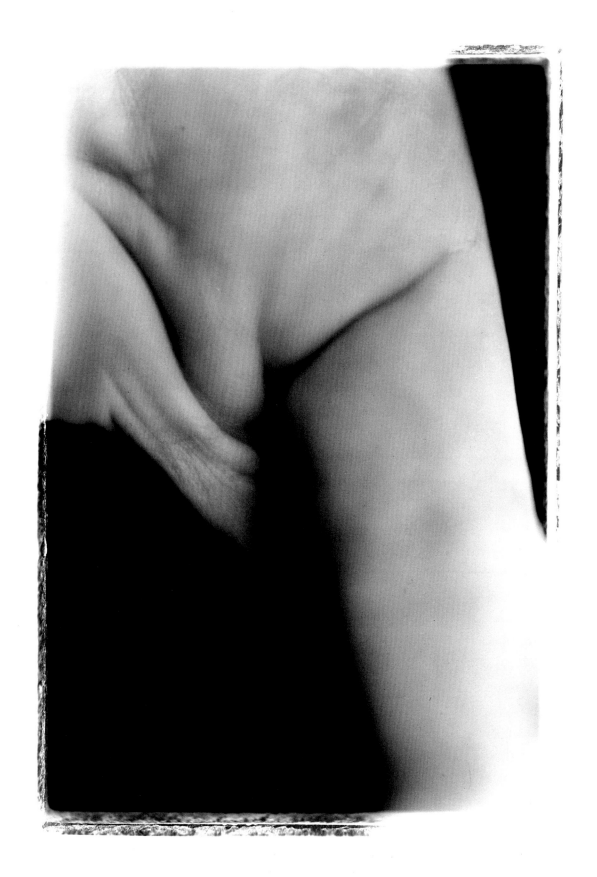

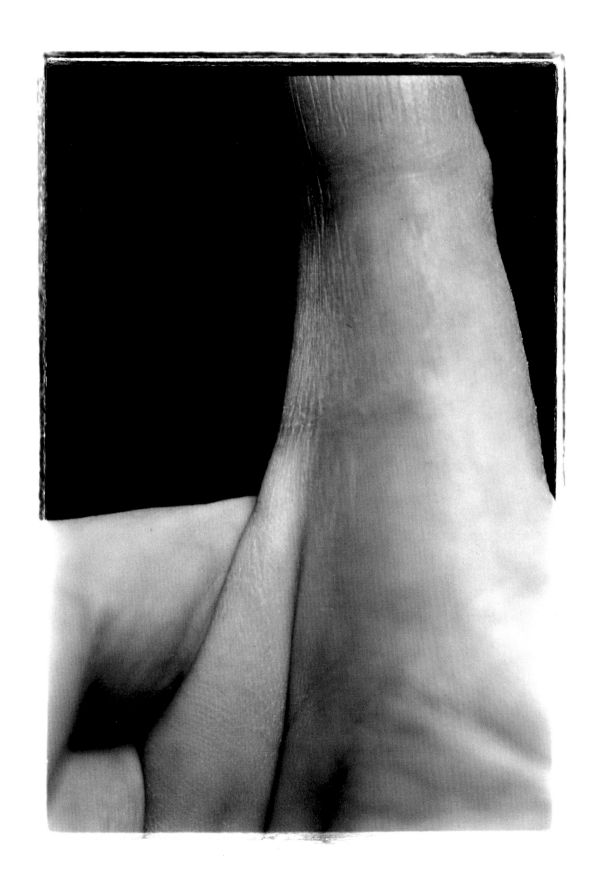

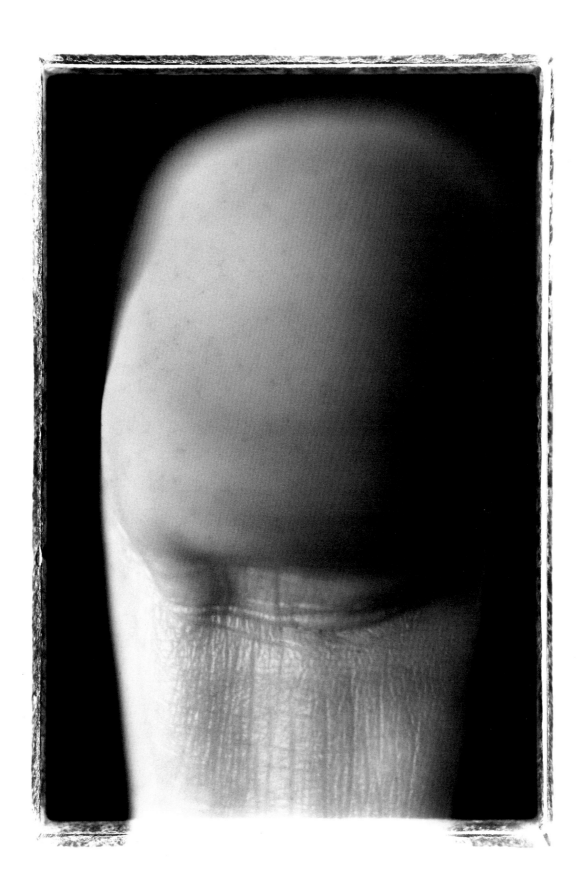

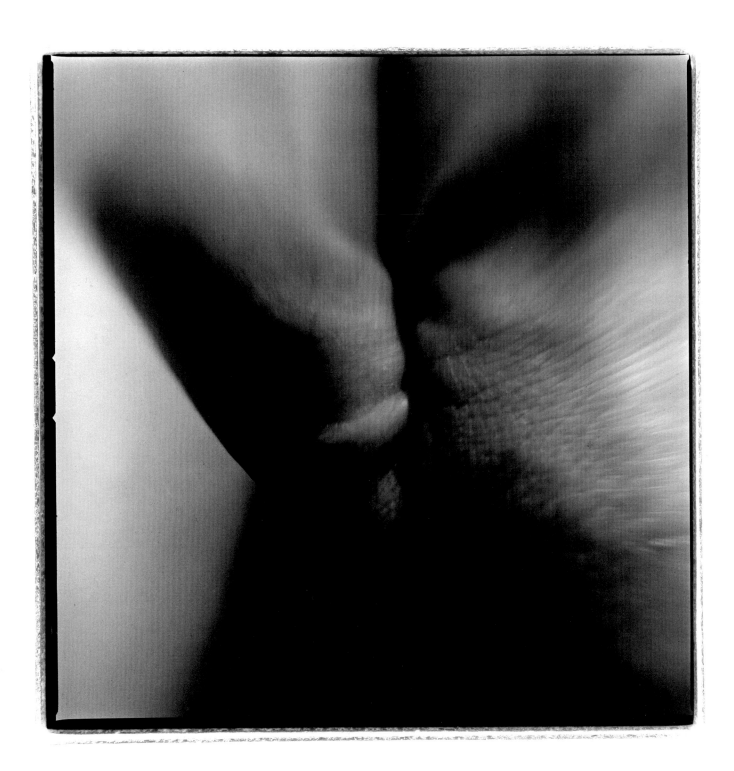

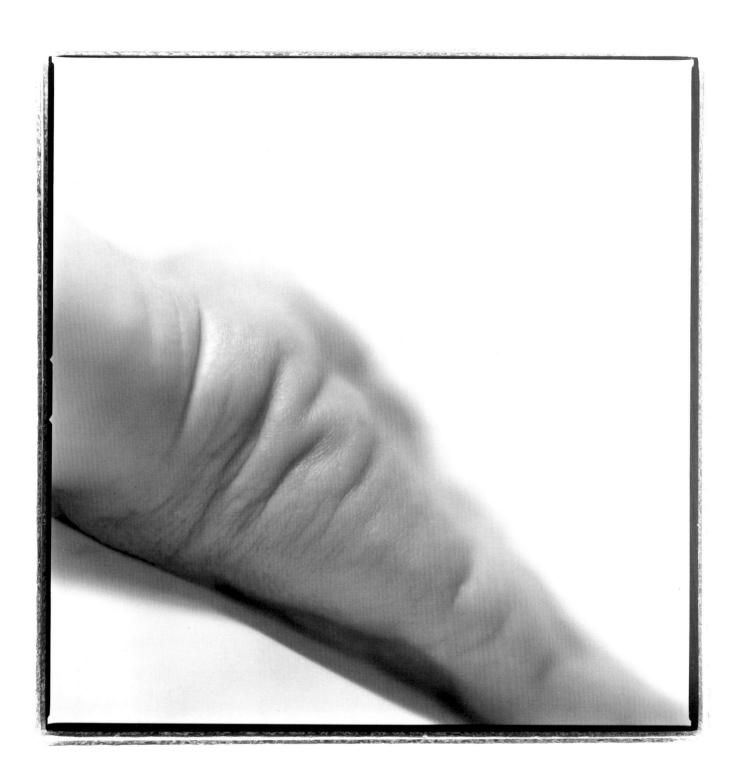

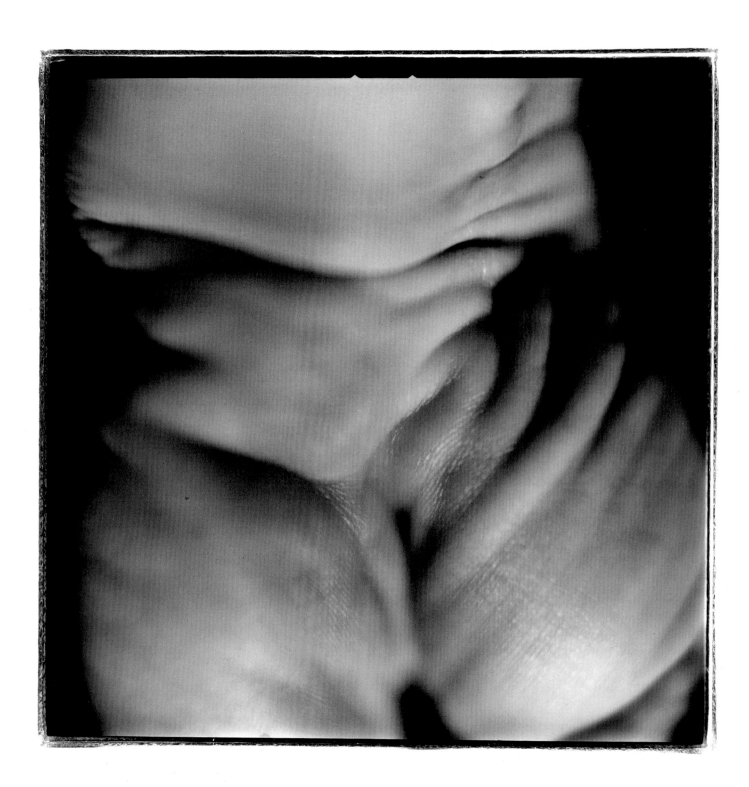

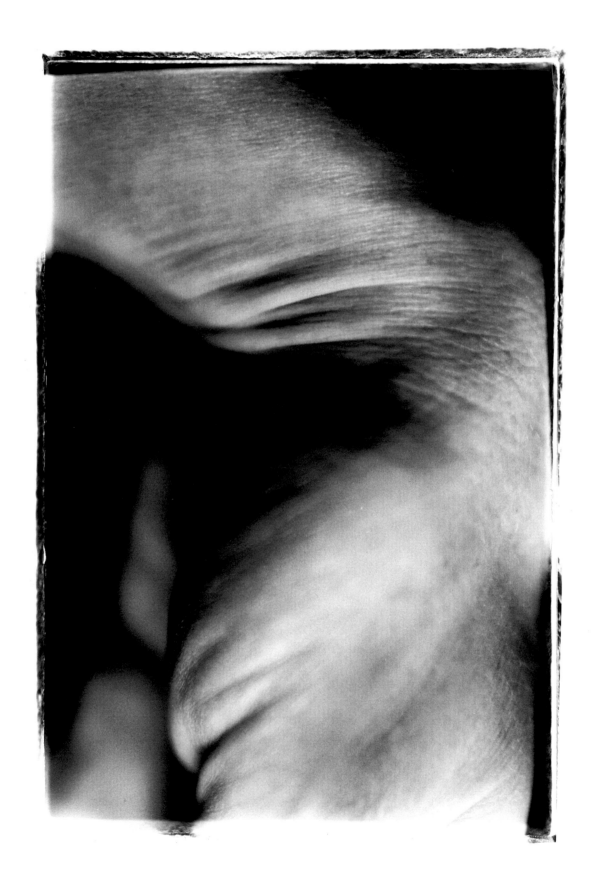

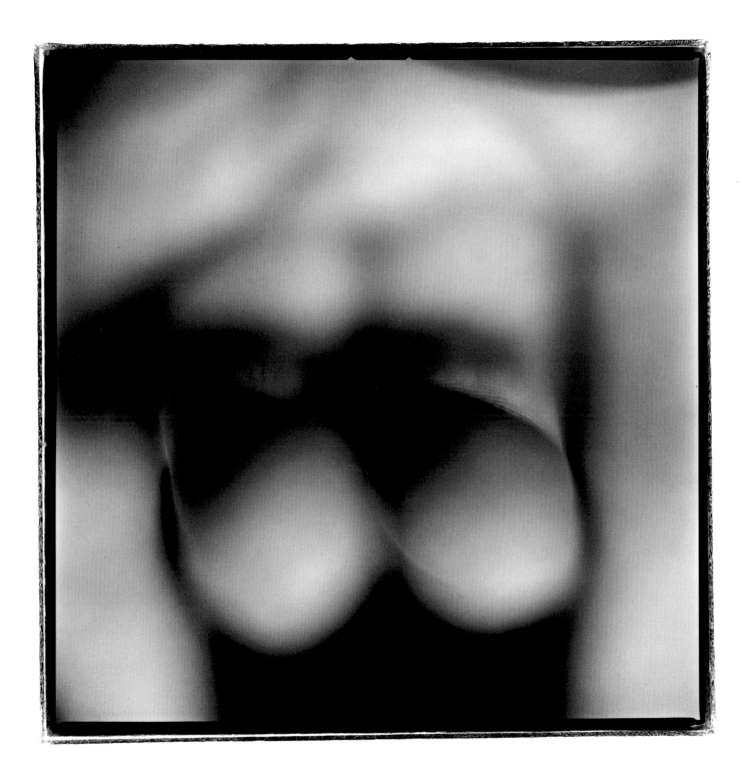

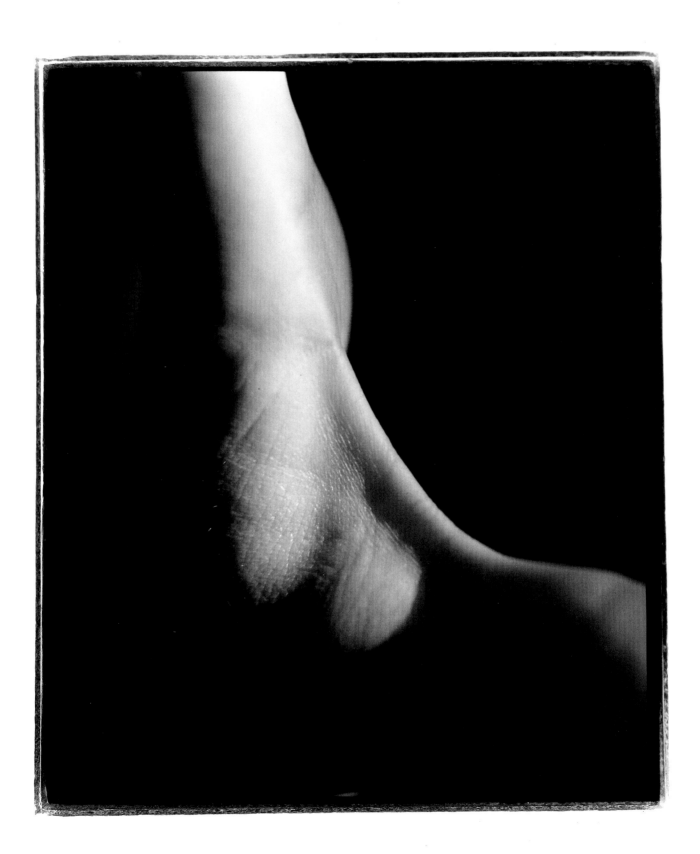

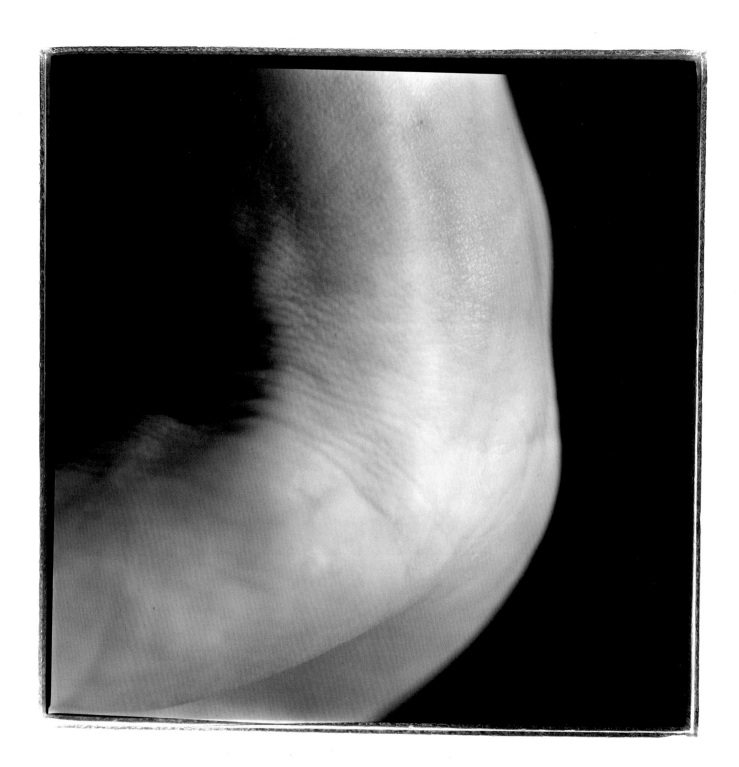

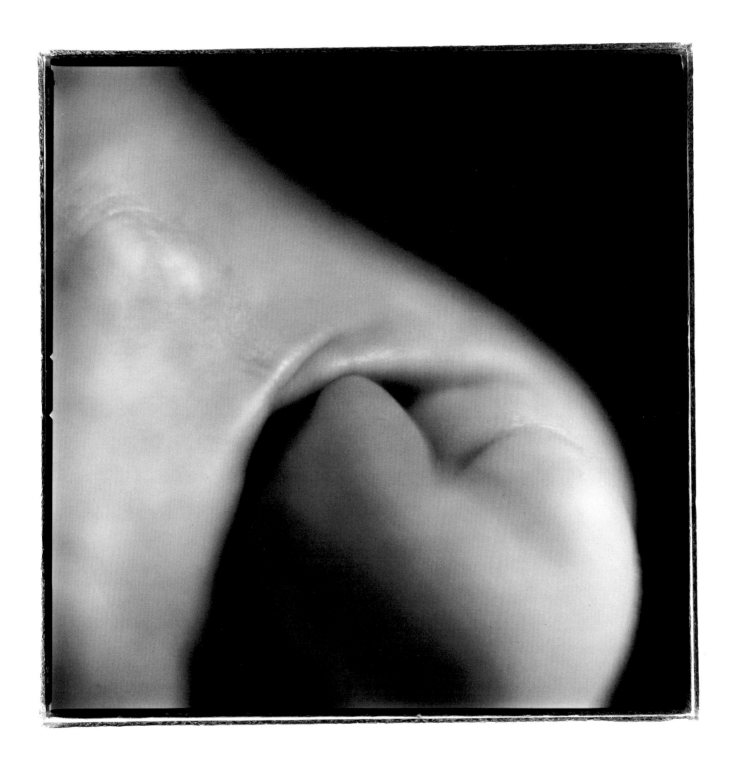

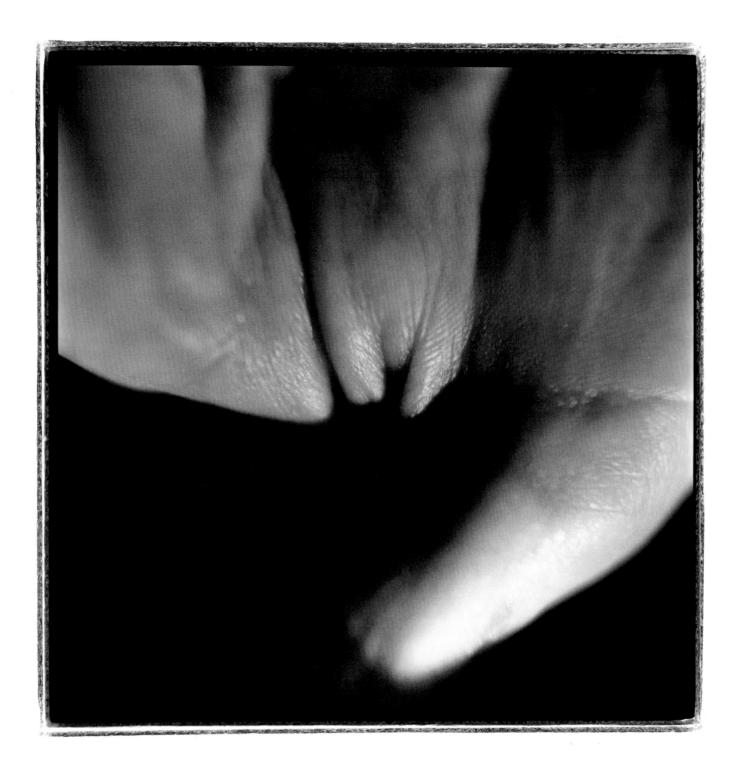

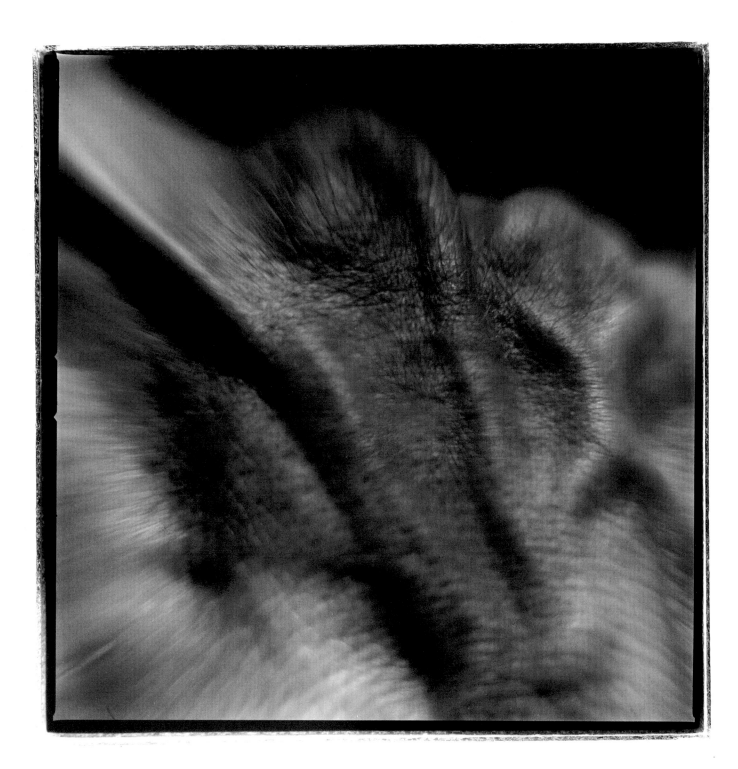

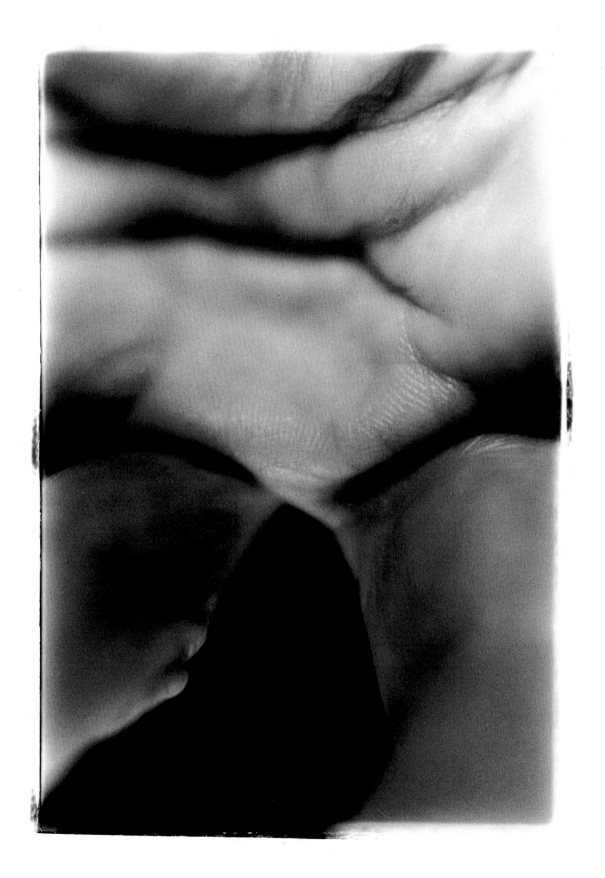

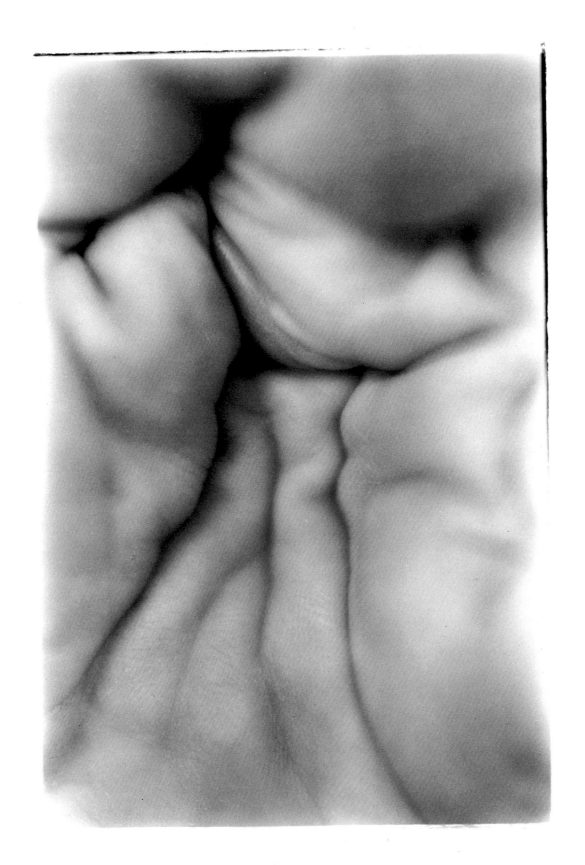

# HOLLY WRIGHT

Born New York City, 1941.

Attended Neighborhood Playhouse, New York City, 1958–59.

Television actress, Hollywood, 1960–63.

Received B.A. in English, University of California, Los Angeles, 1967.

Attended University of Iowa, Iowa City, enrolled in Photography Program, 1974–75.

Lecturer, Photography, Laguna Beach School of Art, California, 1979–1983.

Assistant Professor of Art, University of Virginia, Charlottesville, 1984–present.

Associate Curator (Photography), Bayly Museum, University of Virginia, Charlottesville, 1986–present.

Received University Research Fellowship, University of Virginia, Charlottesville, 1988.

Received Professional Fellowship, Virginia Museum of Fine Arts, Richmond, 1988–89.

Lives in Charlottesville, Virginia, with her husband, the poet Charles Wright, and son Luke.

## INDIVIDUAL EXHIBITIONS

1978    "Gun Yoga and Other Photographs," Hobart-William Smith Colleges, Geneva, New York.

    BC Space, Laguna Beach, California.

1981    BC Space, Laguna Beach, California.

1982    "Face Value: Recent Photographs," Orange County Center for Contemporary Art, Santa Ana, California.

1983    Ricardo Barreto Contemporary Art, Boston, Massachusetts.

    "Applause and Other Photographs," BC Space, Laguna Beach, California.

1984    Fayerweather Gallery, University of Virginia, Charlottesville.

1986    "Final Portraits," Marsh Gallery, University of Richmond, Richmond, Virginia.

    "Moving Pictures," BC Space, Laguna Beach, California.

    "The Real Thing," University of Southern Illinois, Carbondale.

1987    "Audience," The Space, Boston, Massachusetts.

1988    Marcuse Pfeifer Gallery, New York City.

## SELECTED GROUP EXHIBITIONS

1978    "Second Annual All-California Photography Exhibition," Laguna Beach Museum of Art, California. Received award.

    "Friends of Photography Members' Exhibition," Carmel, California.

1979    "Our Own Artists," Newport Harbor Art Museum, California.

1980    "Alternatives 1980," Ohio University, Athens, Ohio. (Traveling exhibition)

    "Magic Silver Show," Murray State University, Murray, Kentucky.

1981    "1981 Photography Auction/Exhibition," BC Space, Laguna Beach, California.

    "11th Annual Works on Paper Exhibition," Southwest Texas State University, San Marcos.

    "57th Annual International Competition," The Print Club, Philadelphia, Pennsylvania. Received the Miller-Plummer Award in Photography.

    "Recent Portraiture," Marcuse Pfeifer Gallery, New York City.

1982    "1982 US Biennial," Museum of Art, University of Oklahoma, Norman.

    "La Nueva Fotografia: Three Young American Photographers," Centro Cultural, Mexico City.

    "Poetic License: Contemporary Artists Interpret Poetry, Drama, Myth, and Other Art," Barreto and DeJesus, Boston, Massachusetts.

    "Whatever Happened to the Avant-Garde?," Orange County Center for Contemporary Art, Santa Ana, California.

1983    "Ooparts: The Uncategorical," BC Space, Laguna Beach, California.

    "The Documentary Portrait," Guggenheim Gallery, Chapman College, Orange, California.

    "The Theatre of Gesture," Los Angeles Center for Photographic Studies, California.

1984    "The Finished Print," The Art Guild, Farmington, Massachusetts.

    "International Art Competition," Los Angeles, California. Received "Silver Medal in Photography" (second prize).

    "Contemporary American Portraiture," ASA Gallery, University of New Mexico, Albuquerque. Received award.

    "American Photography Today 1984," University of Denver and Boulder Center for the Visual Arts, Colorado. (Traveling exhibition)

    "Photography Since 1970," Allen Art Museum, Oberlin College, Ohio.

1985    "BCibachrome," BC Space, Laguna Beach, California.

    "Recent Acquisitions," Bayly Art Museum, University of Virginia, Charlottesville.

1986    Barreto Contemporary Art, Guadalajara, Mexico.

    "LACPS Auction Exhibition," Los Angeles Center for Photographic Studies, California.

1987    Marcuse Pfeifer Gallery, New York City.

## BIBLIOGRAPHY

### Published Illustrations

*Afterimage*, vol. 7, no. 8, March 1980, cover and pp. 12–15.

*Artweek*, October 20, 1979, p. 6.

*Artweek*, February 20, 1982, p. 7.

*Darkroom Art*, Jerry Burchfield, Amphoto, New York, 1981, p. 142.

*The Finished Print* (exhibition catalogue), The Art Guild, Farmington, Massachusetts, 1984, p. 16.

*Foraging*, David Young, Wesleyan University Press, Middletown, Connecticut, 1986, cover.

*Gettysburg Review*, vol. 1, no. 3, Summer 1988, pp. 569–576.

*LACPS Auction* (exhibition catalogue), Los Angeles Center for Photographic Studies, 1986, lot nos. 15, 105.

*Obscura*, vol. 1, no. 5, May–June 1981, "Cheap Shots," pp. 4–6.

*Ontario Review*, no. 10, 1979, "Photofiction," cover and five illustrated short stories by Holly Wright, pp. 33–39.

*Ontario Review*, no. 27, 1987–88, "Corpus Delicti," cover and pp. 51–58.

*Our Own Artists* (exhibition catalogue), Newport Harbor Museum of Art, 1979, p. 164.

*The Portrait*, U-Turn Monograph 2, Denis Grady and James Hugunin, Los Angeles, 1985, p. 8.

*57th Annual International Competition* (exhibition catalogue), The Print Club, Philadelphia, Pennsylvania, 1981, p. 4.

*11th Annual Works on Paper Exhibition* (catalogue), Southwest Texas State University, San Marcos, 1981, p. 1.

### Critical Articles and Reviews

Chenoweth, Ann. "Liz Kreglow/Holly Wright," *New Art Examiner*, June 1986, p. 50.

Ewing, Robert. "Overcoming Nostalgia," *Artweek*, February 20, 1982, pp. 7–8.

Gamwell, Lynn. "A Closer Look at Orange County," *Artweek*, October 20, 1979, p. 6.

Grady, Denis. "Fire and Ice: Thoughts on Projection...," *The Portrait*, U-turn Monograph 2, Los Angeles, California, 1985, pp. 3–9.

Howard, Richard. "One Flesh," *The Gettysburg Review*, vol. 1, no. 3, Summer 1988, pp. 569–576.

Hugunin, James. "Holly Wright and Linda Lindroth: Notions of Presence and Absense (sic)," *Afterimage*, vol. 7, no. 8, March 1980, pp. 12–15.

Hugunin, James. "A Show of Hands," *Artweek*, November 19, 1983, p. 11.

*The Village Voice*, "Choices," April 5, 1988, p. 53.

Wilson, William. *Los Angeles Time*, November 4, 1979, p. 99.

Wong, Herman. *Los Angeles Times*, April 4, 1986, Calendar Section, pp. 1, 17.

Wright, Holly. "On Posing as the Truth," exhibition catalogue essay for *Posing as the Truth: Recent Acquisitions in Photography*, Bayly Art Museum, University of Virginia, Charlottesville, 1988.

## CATALOGUE OF THE EXHIBITION

The Exhibition consists of twenty-seven silver gelatin photographs taken between 1986 and 1988. Thirteen images are 18 x 26 inches, or the reverse; twelve are 20 x 20 inches; two are 3½ x 5½ inches, height preceding width; all dimensions are approximate. Photographs courtesy Marcuse Pfeifer Gallery, New York City.

The work in this exhibition is dedicated to the memory of Chloe Young.

H.W.

This is one of a series of one-person exhibitions, *Photography at the Corcoran,*
co-organized by Associate Director and Chief Curator Jane Livingston and Assistant Curator
Frances Fralin. It is supported by the Professional Division of Eastman Kodak Company.

Copyright © 1988 The Corcoran Gallery of Art, Washington, D.C.

Library of Congress Catalogue Card Number 88-071960

ISBN 0-88675-026-1

Two thousand copies of this catalogue were printed by
Gardner Lithograph, Buena Park, California.

Design: CASTRO/HOLLOWPRESS

Visual Studies Workshop
Research Center
Rochester, N.Y.
August 1989
Gift of the Gallery